Kodak's Most Basic Book of 35 mm Photography

Kodak's Most Basic Book of 35 mm Photography

Written by Jeff Wignall

Front cover photo by Bill Cafer

©Eastman Kodak Company, 1993
Second Edition, 1996 Second printing, 1998

Publication AC-220
CAT No. E893 2998
Library of Congress Catalog Card Number 93-70001
ISBN 0-87985-046-9
Printed in the United States of America

Kodak
LICENSED PRODUCT

The Kodak materials described in this book are available from dealers of Kodak photographic products.

KODAK is a trademark of Eastman Kodak Company used under license. KODACHROME, EKTACHROME, PHOTO CD, and T-GRAIN are trademarks of Eastman Kodak Company.

KODAK Books are published under
license from Eastman Kodak Company by
 Silver Pixel Press®
 21 Jet View Drive
 Rochester, NY 14624
 Fax: (716) 328-5078

Contents

Introduction

If you've got one of those new do-everything computer-controlled cameras that do so much you never quite feel worthy of it, join the crowd. But don't let your camera make you feel left out. It still needs you. After all, it's you who takes the picture.

And if you have a simpler camera, you'll also fit in. Because, again, it's you who takes the picture. The point of this book is to teach you a few basics about your camera, lenses, and flash unit. Those basics apply whether it's that computer-controlled camera taking care of them, or you.

Once you start to understand the basics, you'll feel confident with your camera and be ready to take some great pictures—like those in this book, most of which were taken by amateur photographers like yourself.

About 35 mm Cameras

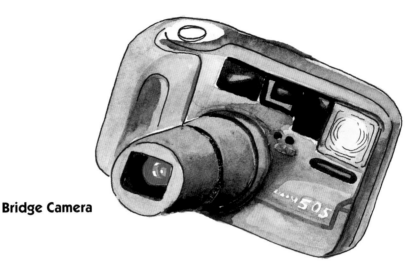

Bridge Camera

Gazing at the dozens of cameras on display in a camera shop might lead you to think otherwise, but there are just three basic types of 35 mm cameras: the lens-shutter camera, the single-lens-reflex, and the bridge camera. All three types are highly sophisticated with many electronic features. Automatic film advance and rewind, automatic exposure control, autofocus, and built-in flash are common to all three types—and each can produce high-quality photographs. The question is, which camera is best for you?

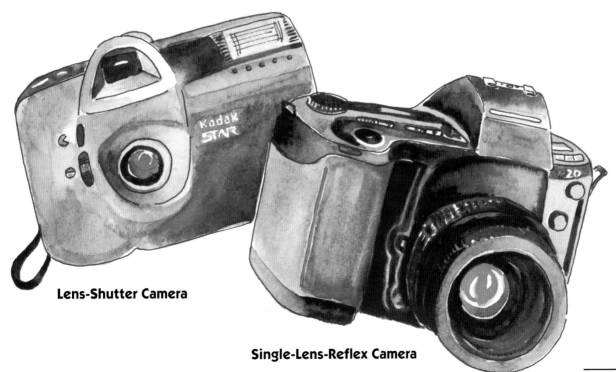

Lens-Shutter Camera

Single-Lens-Reflex Camera

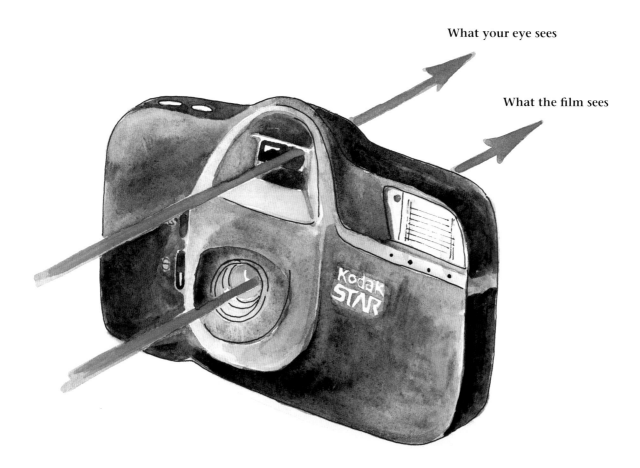

What your eye sees

What the film sees

Lens-Shutter Cameras

Designed for casual photography, these are the simplest of the three camera types. Called lens-shutter cameras because the shutter is built into the lens, they are also referred to as compact or point-and-shoot cameras because of their small size and easy use. Virtually all of the controls are automated and require no adjustments. Unlike SLR cameras, the viewfinder of a lens-shutter camera is separate from the picture-taking lens. This design makes the camera small, but for subjects only a few feet away, it means you have to frame them carefully to avoid clipping off feet or heads in your pictures.

Single-Lens-Reflex Cameras

The single-lens-reflex (SLR) camera has a more complex viewing system. It lets you see your subjects through the actual picture-taking lens. The lens gathers the image and bounces it off a mirror and into the viewfinder. This lets you see almost exactly what the camera sees and what the film is recording—a feature that presents a significant advantage in many picture-taking situations.

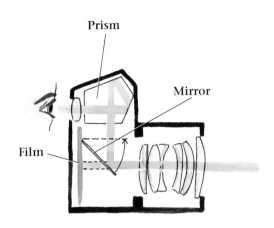

When you press the shutter button, the mirror flips up. The image you saw in the viewfinder now reaches the film to make a picture.

A big advantage of SLR cameras is that you can change lenses. As we will see later, this enables you to interpret subjects in a lot of different, and often dramatic, ways. SLR cameras also have many creative controls. For creative photography, SLR cameras are the runaway favorite.

Bridge Cameras

Bridge cameras, the third category, combine some of the features of lens-shutter and SLR cameras. Like SLRs, most bridge cameras let you see your subject directly through the picture-taking lens. Unlike SLRs, they don't accept other lenses. Instead, bridge cameras use a built-in zoom lens that lets you change the size of the image at the touch of a button. Like lens-shutter cameras, bridge cameras are usually more automated than SLRs.

Camera Features and Controls

Lens-shutter cameras have the simplest outward appearance of all 35 mm cameras because they offer the fewest control options. Features and controls common to most lens-shutter cameras include the shutter release button, autofocus windows, and built-in flash.

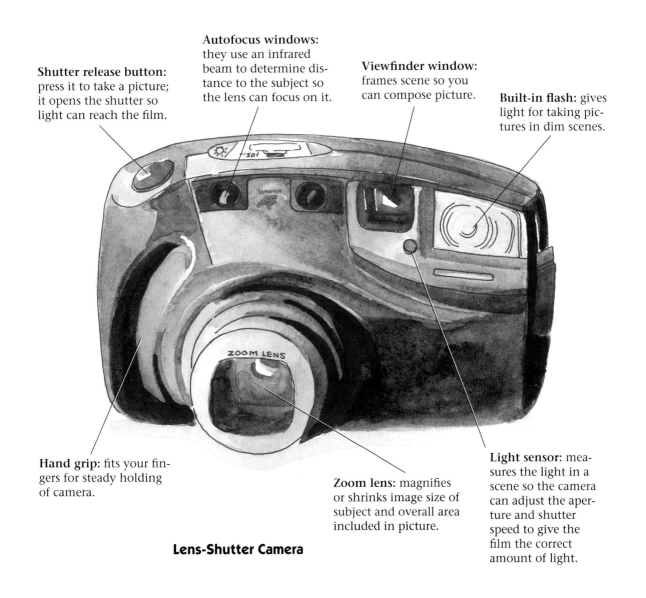

Autofocus windows: they use an infrared beam to determine distance to the subject so the lens can focus on it.

Shutter release button: press it to take a picture; it opens the shutter so light can reach the film.

Viewfinder window: frames scene so you can compose picture.

Built-in flash: gives light for taking pictures in dim scenes.

Hand grip: fits your fingers for steady holding of camera.

Zoom lens: magnifies or shrinks image size of subject and overall area included in picture.

Light sensor: measures the light in a scene so the camera can adjust the aperture and shutter speed to give the film the correct amount of light.

Lens-Shutter Camera

Liquid crystal display panel (LCD): shows camera status, including picture number, exposure mode, shutter speed, *f*-number, low batteries, film loading, and more.

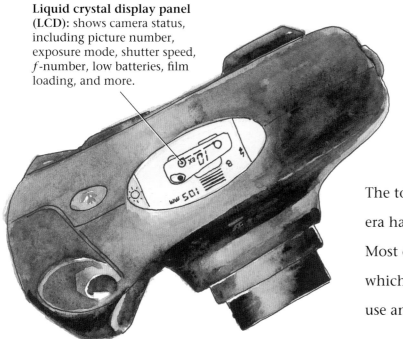

The top of a typical lens-shutter camera has few features and controls. Most obvious here is the LCD panel which displays the lens focal length in use and the number of pictures taken.

The viewfinder display is also simplified. The rectangle in the center is the focusing frame. The other marks indicate the edge of the picture when using the macro feature. You need to adjust the alignment because the viewfinder doesn't show exactly what the taking lens sees at very close range.

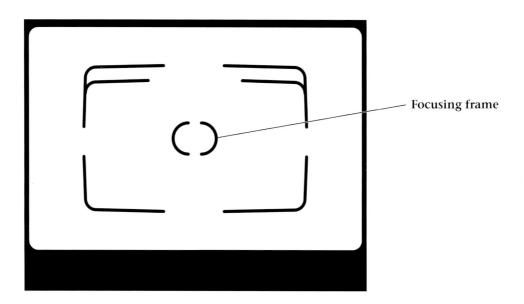

Focusing frame

At first glance, it's hard to imagine that all of the electronic buttons, switches and computer displays on the outside of an autofocus SLR camera will "simplify" your picture-taking. But tackled one at a time, the controls and features are logical and easy to understand. As you become more experienced, you'll come to appreciate the cleverness of their design. The controls on your camera likely differ from those below and on the next page, but they'll cover many of the same functions.

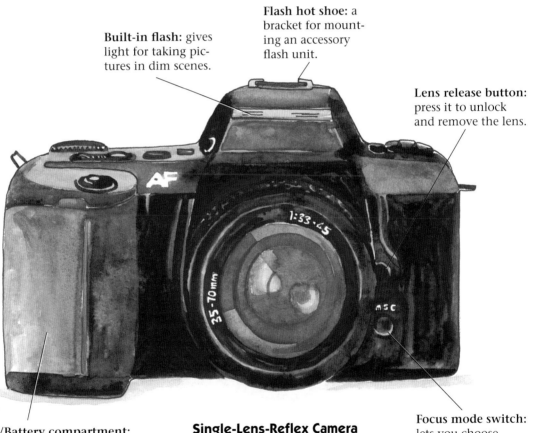

Flash hot shoe: a bracket for mounting an accessory flash unit.

Built-in flash: gives light for taking pictures in dim scenes.

Lens release button: press it to unlock and remove the lens.

Hand grip/Battery compartment: fits your fingers for steady holding of camera and holds batteries that power camera.

Single-Lens-Reflex Camera

Focus mode switch: lets you choose between manual focus and autofocus.

Multi-function control: press this to choose from several functions, such as exposure mode, type of film advance, film speed over-ride.

Exposure compensation button: increases or decreases the exposure by a value you set.

Shutter release button: press it to take a picture; it opens the shutter so light can reach the film.

Self-timer button: press it and run to get into the picture—the camera will take a picture in a few seconds.

Power ON/OFF switch: turns the camera on and off.

Liquid crystal display panel (LCD): shows camera status, including picture number, exposure mode, shutter speed, f-number, low batteries, film loading, and more.

Command input control dial: lets you choose options for different functions, such as film speed and type of exposure mode.

Almost all of the controls on top of an autofocus SLR relate to one of three basic picture-taking functions: light metering, exposure control, and electronic flash. The LCD panel is like a computer screen that lets you see all of the camera's settings at a glance. Other controls include the shutter release button and the power on-off switch.

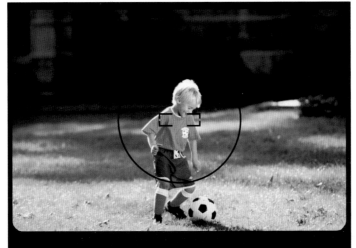

Flash ready light: it glows when the flash is ready for picture-taking.

Aperture indicator: indicates the *f*-number or aperture set by the camera.

Autofocus indicators: indicate whether the lens has focused on the subject.
✗ glows when the camera can't autofocus on the subject
▶ glows when the subject is too near
● glows when the subject is in focus
◀ glows when the subject is too far

Shutter speed indicator: indicates the shutter speed set by the camera. You usually read it as a fraction; here "500" means 1/500 second.

Exposure mode indicator: indicates the mode the camera is using. "P" typically stands for program, "A" for aperture priority, "S" for shutter priority, and "M" for manual.

Most SLR cameras also display a lot of data in the viewfinder. This puts important information right in front of your eye when you're taking a picture. A typical viewfinder display shows you the exposure mode, aperture, shutter speed, and signals for flash and autofocus.

Viewfinder eyepiece: frames the scene so you can compose it for picture-taking.

Focus/Exposure lock: Lets you lock in focus or exposure for scenes that may fool the camera.

Film window: shows area on film magazine that indicates type of film and the number of exposures.

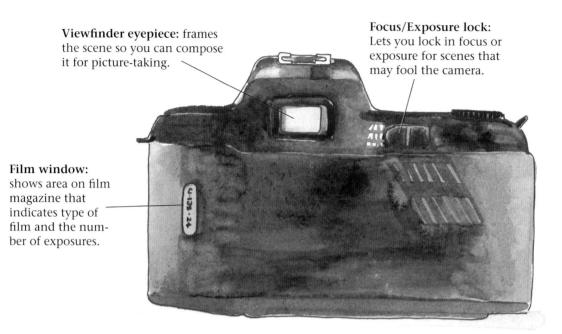

Although there are far fewer controls on the back and bottom of a 35 mm camera than on the front, it's just as important to understand their functions. The most significant is the viewfinder eyepiece through which you compose and focus the picture.

Battery compartment cover: press the release to open the cover.

Tripod mount: threads onto screw on a tripod.

Film rewind button/Film rewind lever: Press both of these at the same time to rewind the film.

Looking inside an SLR camera will teach you a lot about how these cameras work. The chamber on the left is where the film magazine sits. The take-up reel on the right is where the film goes when you advance it. The curtained window in the center is the shutter.

Pressure plate: holds film flat.

Take-up reel: winds up film each time you take a picture.

Shutter curtain: opens when you press shutter button to let light hit film.

DX sensors: read the checkerboard pattern on film magazine to set film speed and film type.

Film chamber: holds the film magazine.

It opens and closes to let light reach (expose) the film. Don't touch the shutter; it's delicate. Other important features include DX sensors (see page 20) and the pressure plate (it keeps the film flat during exposure).

Getting Started

Before you load film into a new camera, be sure to read and understand the instructions in the camera manual (you'd be surprised how many people ignore this advice). Most newer 35 mm cameras offer automatic film loading. They make film loading easier, but you still have to be sure to start the film correctly so it advances properly. If the film doesn't advance, you won't get any pictures!

Film window

Loading Film

Before you open the camera back, always check the film window to be sure that the camera isn't already loaded. If you open a loaded camera in mid-roll, you'll fog the film and you may lose all of your pictures.

After you open the back, set the film magazine into the empty chamber in the camera opposite the take-up reel. Lay the film leader flat across the inside of the camera and be sure that the film magazine stays in place.

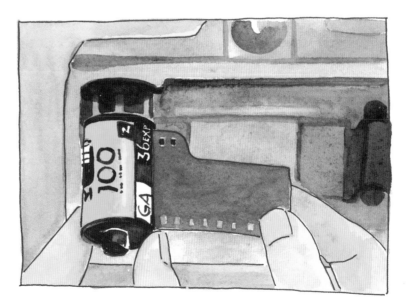

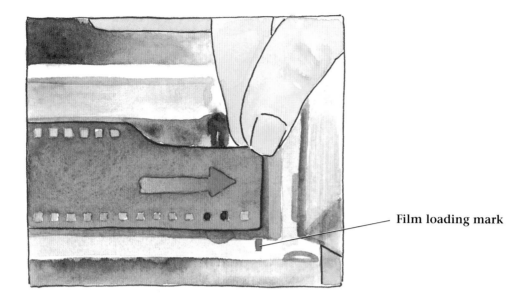

Film loading mark

Pull out just enough film so the tip of the leader meets the loading mark by the take-up reel. The film should still be flat across the back of the camera. If there is any slack in the film, gently slide the excess film back into the magazine. But be careful not to press on the shutter area—it's very delicate and easily damaged. Check that the teeth on the take-up reel stick through the film perforations. Read your camera manual for instructions for the type of camera you own.

Teeth in film perforations

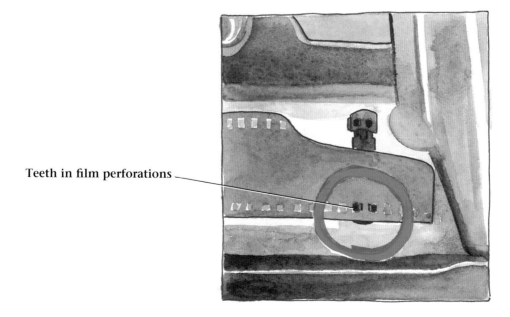

Frame number: indicates number of pictures you have taken

When you close the back of an autoload camera, the film will automatically advance to the first frame. If the film is loaded properly, the LCD panel will indicate that the film is at frame number 1. The camera is ready for picture-taking.

Error message

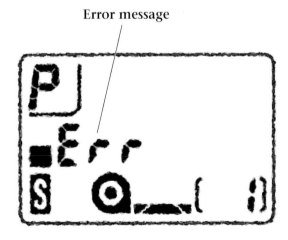

The LCD panel on some cameras will display a loading-error symbol if the camera is not properly loaded. This is typically a drawing of an open-camera back or the letters "Err" or "E" (error). Open the camera and repeat the loading steps, or refer to the instructions in your camera manual.

Setting the Film Speed

For correct exposure, cameras with built-in meters need information about a film's sensitivity to light. This is called film speed. On older cameras, you set the film speed manually by turning a film-speed dial.

Many newer cameras have electronic sensors that read the silver-and-black checkerboard patterns, called DX codes, printed on most 35 mm film magazines. By reading the codes, the camera sets the film speed automatically. DX codes also contain information about the type of film and the number of exposures on the roll.

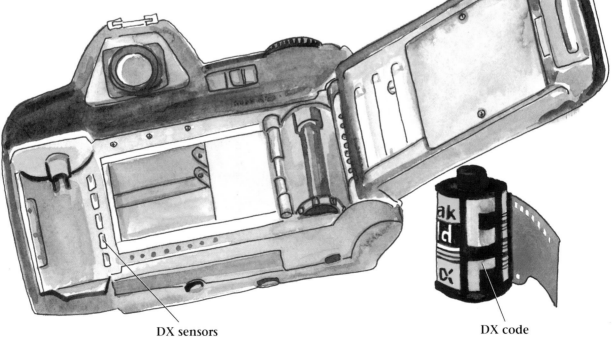

DX sensors DX code

Rewinding and Unloading

Cameras that load film automatically, usually rewind it automatically. The camera may automatically rewind after the last exposure, or it may signal you to press a rewind switch to begin the rewind. Don't open the camera until you hear the rewind motor stop.

Check that the camera completely rewound film into the magazine. If you have an auto-rewind camera that leaves a small tail of film leader sticking out of the magazine, gently push the film back through the slot. This prevents you from accidentally reloading and double-exposing the same roll.

Lenses

Perhaps the greatest advantage of SLR cameras is their ability to accept a wide array of different focal length lenses. By simply changing lenses, you can produce very different views of the same subject—and you can photograph subjects that might be too far away for a simpler camera.

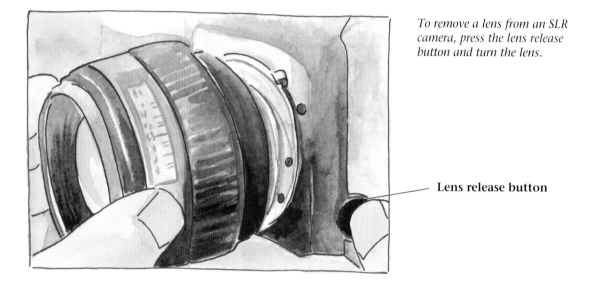

To remove a lens from an SLR camera, press the lens release button and turn the lens.

Lens release button

Just remember that most lenses will fit only specific SLR camera brands or models. This is especially true of autofocus cameras and lenses. Some independent lens makers sell lenses to fit several different brands of cameras, so check before you buy. You also want to be sure that the lens will work on your camera without sacrificing any of your camera's automatic capabilities.

Lens Speed

One way lenses are described is by their light-gathering ability or speed. The largest aperture for a lens determines its speed number, which is usually marked on the front of the lens barrel. Just remember, the smaller the number, the faster the lens. Therefore, an $f/2$ lens is faster than an $f/2.8$ lens, and slower than an $f/1.8$ lens. For more about apertures, see page 74.

Because faster lenses let in more light, they are good for action shots or taking pictures in dim light. Faster lenses also cost more and are usually larger and heavier.

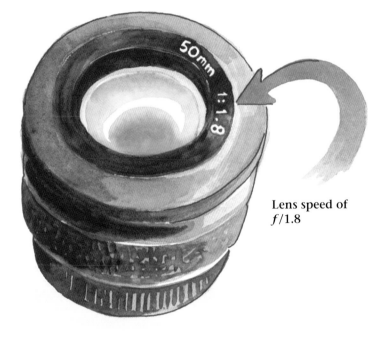

Lens speed of $f/1.8$

Focal Length

Lenses are also described in terms of their focal length. This is an optical measurement. It is measured in millimeters. The focal length of a lens determines the lens' angle of view—how much area the lens can cover. Focal length also controls how large or how close subjects will look.

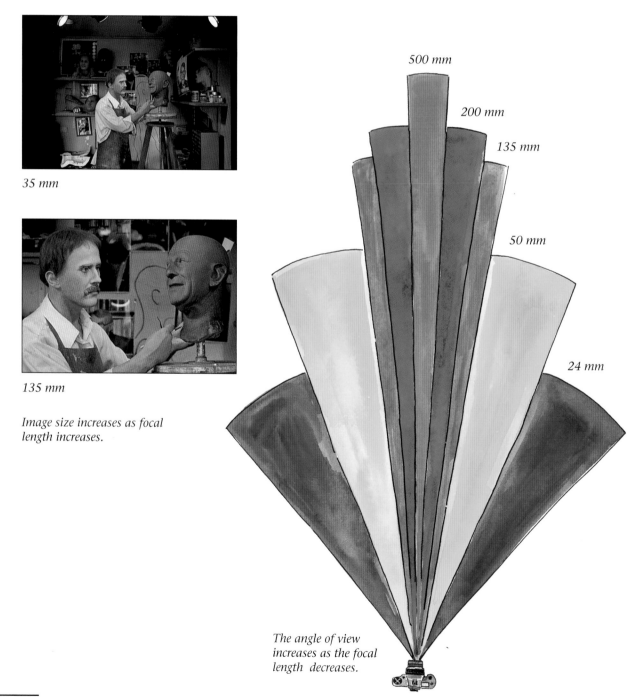

35 mm

135 mm

Image size increases as focal length increases.

500 mm

200 mm

135 mm

50 mm

24 mm

The angle of view increases as the focal length decreases.

Normal Lenses

The "normal" lens for a 35 mm camera is one with a focal length between 40 and 58 mm. This is often the standard lens that comes with a new camera. It's called "normal" because it closely matches how our eyes see the world. A normal lens is ideal for the times when you want to render scenes with normal perspective and size relationships.

Wide-Angle Lenses

Lenses with a focal length shorter than a normal lens are called wide-angle lenses. Wide-angle lenses take in a broader view of the world than normal lenses. This makes them a favorite tool of landscape photographers. The shorter the focal length, the wider the view. The most popular wide-angle focal lengths are between 21 mm and 35 mm.

The ability of a wide-angle lens to pull in wider views also comes in handy when there's simply no room to back further away from your subject—such as indoor shots or other narrow confines.

One caution: Wide-angle lenses distort the size and shape of nearby objects. Standing too close when you take a portrait can give subjects an unflattering—even comical—appearance. The closer you get, and the shorter the focal length, the more distorted your subject will become.

Shooting up from the base of a tall subject, such as a building, with a wide-angle lens creates an interesting perspective distortion called keystoning. The vertical lines of the building converge to further exaggerate its height.

Telephoto Lenses

Telephoto lenses have focal lengths longer than a normal lens. They range in length from around 85 mm to 1200 mm. Telephoto lenses magnify the subject, so it looks closer. They also have a narrow field of view. Telephoto lenses are almost a must for sports and wildlife photography, and moderately long focal lengths (100–135 mm) are useful for portraits.

Normal lens, 50 mm

Telephoto lens, 200 mm

To get sharper pictures with a telephoto lens, use a tripod and a cable release, or a fast shutter speed such as 1/250 second. Because telephoto lenses are heavy, they tend to magnify camera movement.

Cable release: lets you open the shutter with minimal movement of the camera

Hand-holding a camera with a big telephoto lens is an invitation to fuzzy pictures. If you don't have a tripod handy, there are other ways to support your camera for sharp pictures, such as resting it on a fence or holding it against a tree to steady it.

Macro Lenses

Macro lenses are specially designed for taking close-up photographs. This makes them a top choice for nature photography and other close-up work. Some zoom lenses for SLR and lens-shutter cameras feature a "macro" mode. While they cannot get as close as true macro lenses, their close-focusing capability can be handy for adding variety to your picture-taking.

28 mm

50 mm

135 mm

The photographer stood in one spot and took these pictures with a 28-200 mm zoom lens.

Zoom Lenses

Zoom lenses are popular because they offer a whole range of focal lengths in one lens. You can stand in one spot, and by simply turning a collar or sliding the lens barrel, you can change the size and framing of your subject. Zoom lenses come in many focal length ranges to cover almost any situation. Some common zoom ranges are 35 mm to 70 mm, 35 mm to 135 mm, and 80 mm to 200 mm.

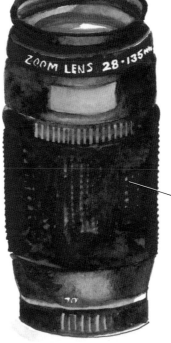

Zoom collar: slides up and down to change focal lengths

Zoom lenses are ideal for lightweight traveling. One zoom can take the place of several fixed-focal-length lenses.

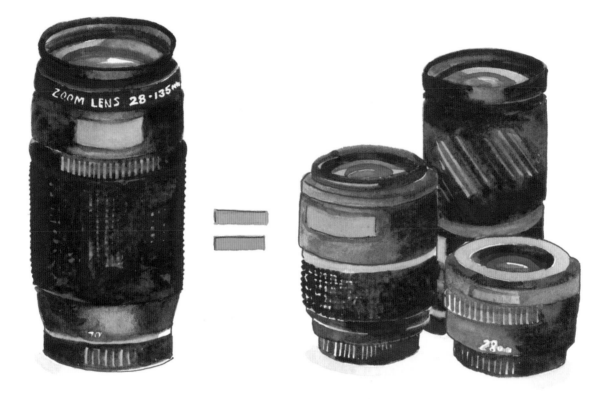

A drawback of many zooms is their relatively slow speed. Most have a maximum aperture between $f/3.5$ and $f/5.6$. This is fine for normal outdoor photography, but it may limit your options in dim light or with fast-moving subjects.

Lens Accessories

Photo taken with orange filter

There are many types of lens accessories available for use with 35 mm cameras. Some are so exotic and specialized that you may never need or use them. Others are common and very practical, and they are well worth considering if you want to enhance your picture-taking. Let's take a look at the most popular accessories and see what each can do for you.

Lens Shades

A lens shade or hood attaches to the front of a lens. Lens shades come in different sizes and shapes to meet the requirements of different lens focal lengths. Their main purpose is to shade the front of the lens and prevent stray light from causing flare, resulting in poor pictures. Lens shades also offer some physical protection for the front surface of the lens.

Close-Up Attachments

Close-up attachments are single-element magnifiers that screw onto the front of the camera lens. They usually come in a set of three lenses of different powers, and you can combine them for even greater magnification.

Also called supplementary lenses, they offer the simplest and most economical approach to close-up photography.

Skylight Filter

The No. 1A, or skylight filter, is used with slide films to reduce the excessive bluishness in pictures taken in the shade or on overcast days. The filter also works to slightly reduce the haze associated with distant scenic pictures. No exposure adjustment is necessary. An extra benefit of a skylight filter is the protection it offers a lens from dust, fingerprints, bumps, and water spray.

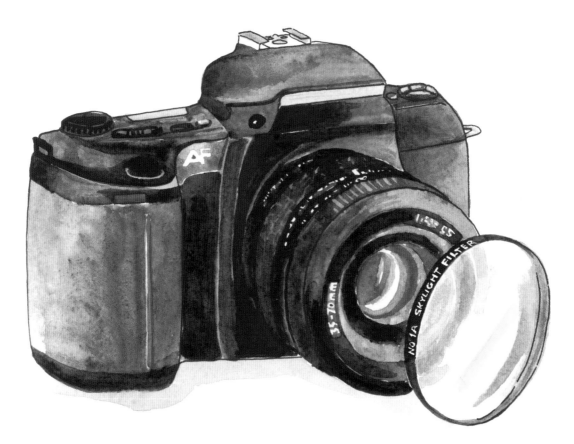

Without polarizing filter

With polarizing filter

Polarizing Filter

A polarizing filter is one of the most useful filters you can own. Its main uses are to darken blue skies, make colors more saturated, and reduce or eliminate reflections from glass and water. If you have an autofocus camera, you may need a special circular polarizer instead of the standard linear version employed by manually-focused cameras. Consult your camera manual for instructions.

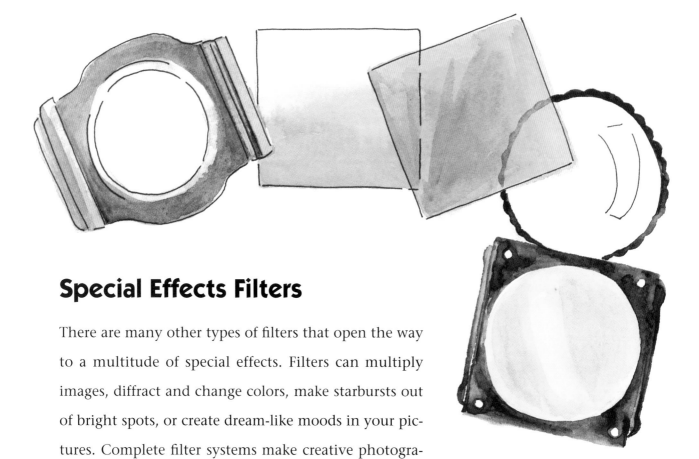

Special Effects Filters

There are many other types of filters that open the way to a multitude of special effects. Filters can multiply images, diffract and change colors, make starbursts out of bright spots, or create dream-like moods in your pictures. Complete filter systems make creative photography so easy that the hardest part may be in deciding which filters to use.

Photo taken with a star filter

Using Electronic Flash

Electronic flash provides a convenient and ready source of light for taking pictures when the existing light is simply too dim for good results. Today's flash units are portable, powerful, and easy to use. Techniques once practiced only by advanced photographers are now available to all just by pressing a button.

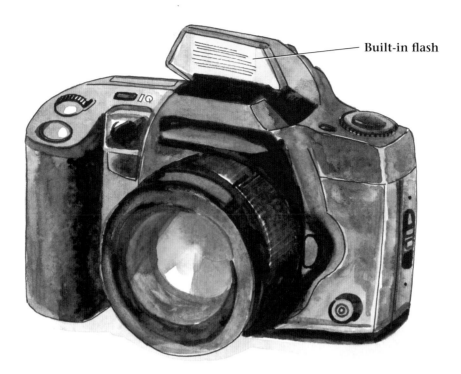

Built-in flash

Built-in Flash Units

Almost all lens-shutter and bridge cameras, and many SLR cameras, have a built-in flash unit. Some need to be turned on or flipped into place when needed; others will flash automatically when the lighting gets too dim. Though handy, most built-in flash units have limited power and versatility—their maximum flash range may be only 15 to 20 feet.

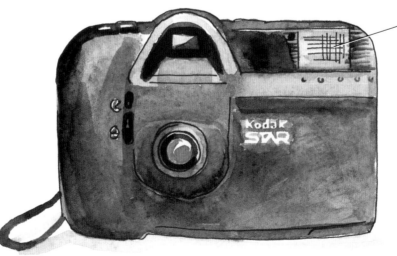

Built-in flash

Flash at the top

The built-in flash on some cameras is at one end of the camera body. Whenever you take a vertical picture with this type of design, be sure that the flash is at the top end. If you hold the camera with the flash below the lens, the angle of the lighting is unnatural and shadows are cast upward. Be careful not to block the flash with your fingers.

Flash at the bottom

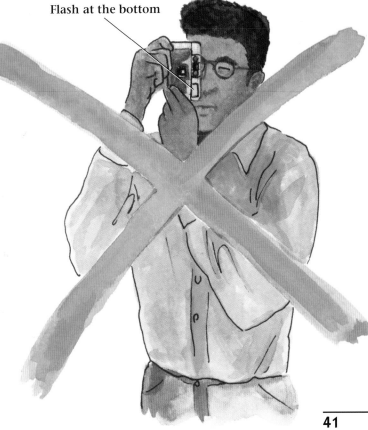

Accessory Flash Units

Accessory flash units are usually more powerful and more versatile than built-in flash. There are three basic kinds: manual, automatic, and dedicated. Manual units are less popular than automatic or dedicated units because you have to set the controls for proper exposure. Automatic and dedicated flash units are much easier to use because they do much of the work for you. Automatic flash units will work with most SLR cameras. A dedicated flash unit is designed to work with a specific camera model.

The bigger the flash unit, the more powerful it usually is.

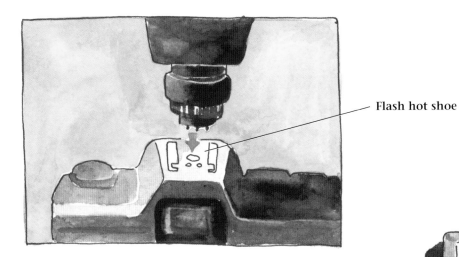

Flash hot shoe

Most SLR cameras have a special place for connecting an accessory flash called a hot shoe. The hot shoe provides the electrical contact that enables the camera to fire the flash when you press the shutter release.

Many cameras also have a PC socket. It accepts a standard flash sync cord to make the connection between the camera and the flash. The flash itself can sit on top of the camera, or you can attach it to a special flash bracket.

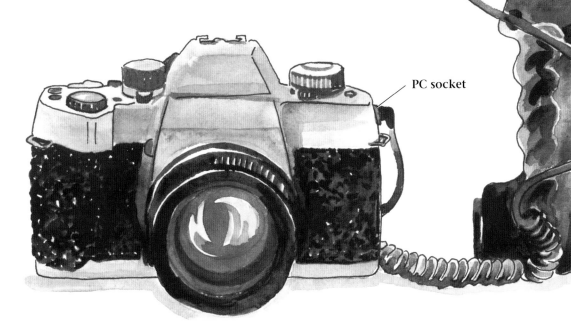

PC socket

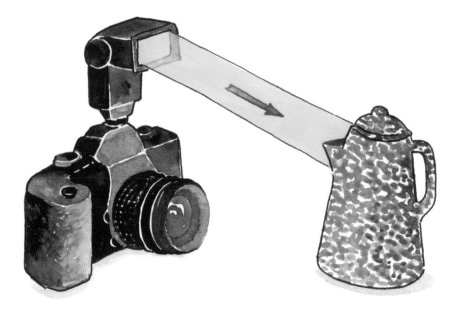

Manual Flash

With a manual flash unit, you have to adjust the flash, the camera, and the lens. That's because a manual unit sends out the same amount of light every time it fires. Since it doesn't adjust the amount of light it sends out, you have to adjust the lens aperture to make sure the film gets the right amount of light.

You first set a dial or scale on the flash unit to the speed of the film you are using. Then you set the shutter speed to the flash shutter (sync) speed, typically 1/60 or 1/125 second. You then determine how far the flash is from the subject. Next, you look up this distance on the dial to see which aperture corresponds to that distance. Then you set the aperture on the lens. Each time you change the distance to the subject, you have to reset the aperture.

Automatic Flash

Automatic flash units are easier to use than manual units. That's because they vary the amount of light they send out. A light sensor on the flash unit measures the amount of light the subject reflects from the flash. When the sensor determines that the flash has produced enough light for a good picture, the flash shuts off.

You still have to refer to a dial on the flash unit and set the lens aperture. But you have less work because the lens aperture you set will work over a distance range, such as 5 to 15 feet. Only when you get out of that range do you have to reset the aperture.

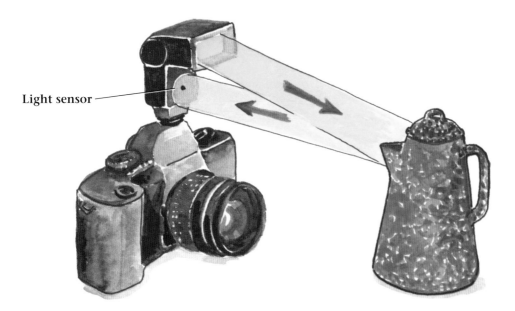

Light sensor

Dedicated Flash

Dedicated flash units are even simpler to use than automatic flash. Dedicated flash units use sensors inside the camera to give the film just the right amount of light. They measure the light coming through the lens and shut the flash off when the exposure is correct. Electrical contacts on the flash enable the camera and flash to exchange information about film speed and camera settings. The most you have to do is turn the flash on. And with some cameras you don't even have to do that. They will automatically turn on and fire the flash when the light is dim. Most dedicated units can also be used as automatic or manual flash units. Remember, most dedicated flash units are made for specific cameras, so be sure a flash is compatible with your camera before you buy it.

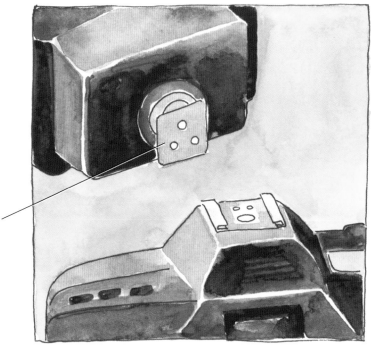

Electrical contact

3 Keys to Using Electronic Flash

1. **Set the lens to the recommended aperture.**

As long as you stay within the indicated distance range for the mode and aperture you are using, the flash will automatically adjust exposure.

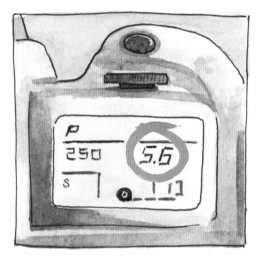

2. **Do not take pictures of subjects beyond the maximum flash distance.**

3. **To be sure of good exposure, wait until the flash-ready light glows before taking the picture.**

Some flash units also have a test button so you can test-fire the flash to check exposure without actually taking a picture. Most autofocus cameras include a flash confirmation or confidence light in the viewfinder to tell you if you got a good exposure.

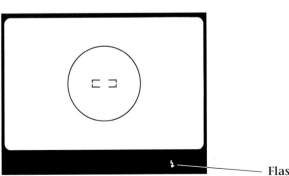

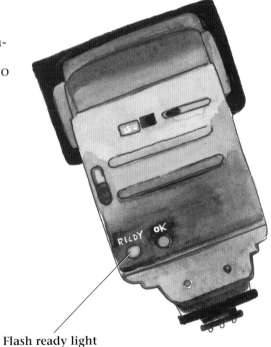

Flash ready light

Fill-Flash

Have you ever thought about using flash outdoors on a sunny day? If you want to make more pleasing portraits, fill-flash can lighten distracting facial shadows, restoring detail and color. The technique is particularly useful for backlit subjects, and it works best with slow- or medium-speed print films.

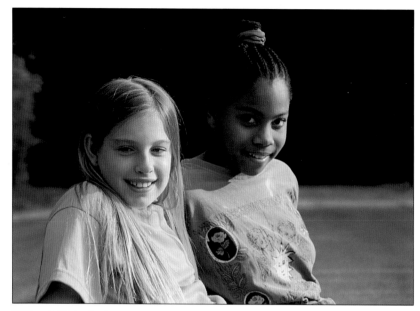

Without fill-in flash

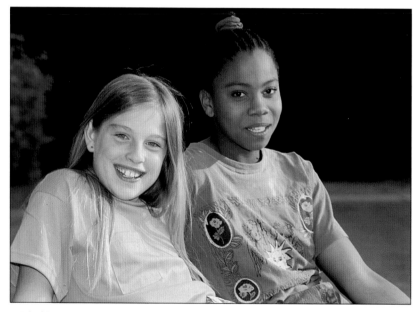

With fill-in flash

Many 35 mm cameras have a fill-flash or flash override feature that forces the flash to fire when you want it to, not just when the camera believes it should. The object of fill-flash is to lighten the shadows subtly, achieving a balanced exposure between the subject and the background. Check your instruction manual for the details.

Flash Troubleshooting

Overexposed

SUBJECTS TOO CLOSE—check the minimum flash distance

Underexposed

SUBJECTS TOO FAR AWAY—check the maximum flash distance

FLASH NOT FULLY CHARGED—wait for flash-ready signal

WEAK BATTERIES—check and replace if needed

Uneven Exposure

SUBJECTS AT DIFFERENT DISTANCES—group together at same distance

Not Properly Synchronized (SLR Camera)

Shutter speed set too high

Reflections

Avoid reflective backgrounds (mirrors, windows, etc.)—stand at an angle

Red-Eye*

- Turn on all the room lights
- Have the subject look away from the flash
- If possible, increase the distance between the flash and the camera (use a flash extender, off-camera flash, or bounce flash)

*Red-eye is the light of the flash reflecting from within the eye. It occurs when the flash and camera lens are close together—a common situation with compact cameras featuring built-in flash. Some cameras have special features to reduce or eliminate red-eye, so check your camera manual.

Choosing a Film

When choosing a film, the first thing you have to decide is whether you want prints or slides. If you want prints, do you want black-and-white or color? You should also pick a film based on the brightness and type of lighting you expect to encounter. Will you be shooting outdoors in bright light, or indoors where the light is less bright? The information on the following pages will help you choose the right film for any situation.

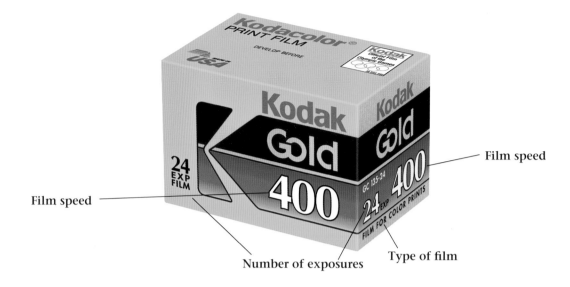

Film speed

Film speed

Number of exposures

Type of film

You'll find important information about a film printed on the box and on the 135 mm film magazine inside. Here are some of the things to look for.

- TYPE OF FILM—slides or prints, color or black-and-white.
- FILM SPEED—the ISO number.
- NUMBER OF EXPOSURES—12, 24, or 36.
- EXPIRATION DATE—don't use out-of-date film.

The inside of the box provides other information, including recommendations for exposure settings and filtration for alternate light sources. The expiration date can be found stamped on the top or the bottom of the box.

Prints

When you take a picture on a print film—color or black-and-white—you get negatives when the film is developed. The photofinisher then makes prints and enlargements from the negatives. He can also make slides from them. An important advantage of most of these films is their exposure latitude— the ability to produce useable pictures even if the film was somewhat over- or underexposed.

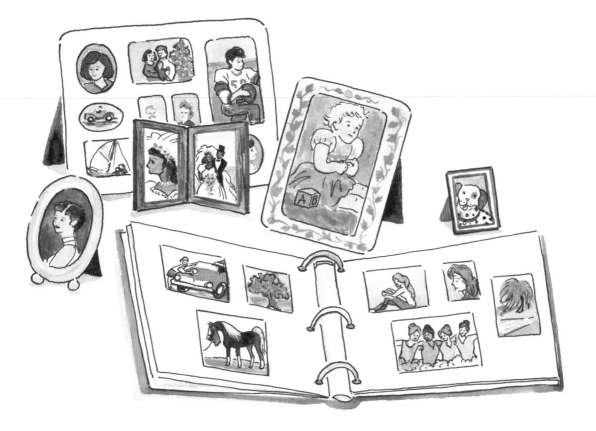

Choose a print film when you want to share photos with others, put pictures into albums, or hang enlargements on your wall.

Slides

With color slide film, the film that you expose in your camera becomes the final picture after processing. The film is mounted in a slide mount, ready for projection. Slides are great when you want to show your pictures to a group of people. Slide films generally have less exposure latitude than print films. Be sure that your camera can accurately expose slide films. Some simpler cameras are designed to use only print films. Your photofinisher can also make prints from a slide. KODACHROME and KODAK EKTACHROME films are favored for slides.

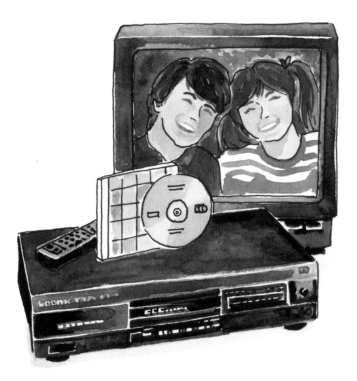

KODAK Photo CD

The KODAK Photo CD system allows you to view your pictures on your television. Simply ask your photofinisher to transfer your pictures onto a KODAK Photo CD Disk for playback on a KODAK Photo CD Player. This can be done from either print films or slide films.

Film Speed

Once you pick the type of film you want, the next thing to consider is film speed. Speed is expressed in terms of ISO numbers or Exposure Indexes (EI), and the number indicates a film's sensitivity to light. The higher the number, the more sensitive the film. Films that are commonly available have speeds ranging from ISO 25 to ISO 1600.

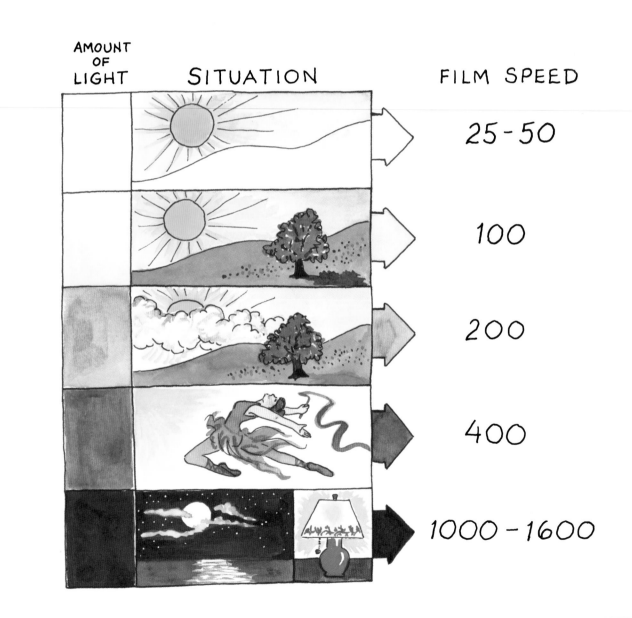

AMOUNT OF LIGHT	SITUATION	FILM SPEED
		25 - 50
		100
		200
		400
		1000 - 1600

Low-speed films (ISO 50 or below) are usually meant for taking pictures in bright daylight since they require a lot of light to produce a good exposure. These films are favored by many users for their excellent grain and sharpness.

Medium-speed films (ISO 64 to 200) will cope with a variety of light levels while providing excellent image quality. They are good choices for all-around use outdoors in daylight.

When you plan to take pictures in both dim light and bright daylight, or you will be photographing both fast-moving and still subjects, consider an ISO 400 film. It has the speed to handle a wide variety of conditions and will carry you through a full day of picture-taking, indoors and out.

For taking pictures in low light, including pictures inside museums, sports arenas, or other dimly lighted locations, choose a very-high-speed film. Films rated at ISO 1000 or 1600 are extremely sensitive to light and are particularly useful when you need fast shutter speeds to stop action.

You may have noticed that some pictures have a sandy or granular texture over the entire image. Generally, this graininess becomes apparent only with faster films. Extreme enlargements or improper exposure will also increase graininess. This example shows a 50X enlarged section of a picture taken on KODACHROME 64 Film.

The introduction of KODAK T-GRAIN EMULSION Technology has resulted in films that are sharper and finer grained than other films of similar speed.

Use this chart to select a film. Notice that 400-speed film is recommended for every picture-taking situation listed. The characteristics of this high-speed film make it a good general-purpose selection for many kinds of situations and subjects.

Film Speed	PICTURE – TAKING SITUATION				
				TELEPHOTO	
25 Speed	VERY BEST	OK	NOT SUITABLE	USE TRIPOD	NOT SUITABLE
100 Speed	BEST	OK	OK	OK	NOT SUITABLE
200 Speed	GOOD	BEST	GOOD	GOOD	NOT SUITABLE
400 Speed	OK	GOOD	BEST	BEST	OK
1600 Speed	NOT SUITABLE	OK	GOOD	OK	BEST

Camera Handling

Hold it Steady and Level

Good pictures start with keeping your camera steady and level. Hold the camera with both hands in a relaxed but firm grip. Get the camera as close to your eye as possible so you can see everything in the viewfinder. With a manual-focus camera, grasp the lens so you can focus without changing your grip.

For vertical pictures, you can position the shutter release at the top or bottom, whichever is most comfortable.

With a compact or autofocus camera, hold the camera with your hands away from the lens. Be careful not to interfere with the operation of the lens, the autofocus window, or the built-in flash.

Stance is important too. Keep your elbows in by your side and stand with your legs about shoulder-width apart. When you're ready to take the picture, hold your breath and gently squeeze the shutter release.

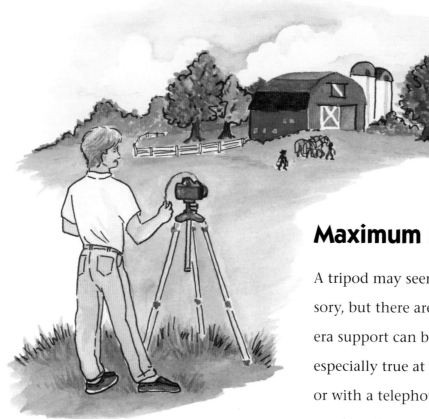

Maximum Steadiness

A tripod may seem like a glamorous accessory, but there are times when extra camera support can be a real necessity. This is especially true at very slow shutter speeds, or with a telephoto or macro lens. In combination, a tripod and a cable release are your best choices for maximum sharpness.

Tripods come in all sizes. The best one is the one you are willing to carry with you so you'll have it when you need it. Monopods are one-legged camera supports that are great in tight spaces or when you want to lighten your load. No tripod available? It's easy to improvise some extra support. A car fender or fence post both work well.

Focusing Techniques

Along with steadiness, sharp focus is one of the prime requisites of a well-made photograph. Some SLR cameras still focus only manually, but virtually all lens-shutter and bridge cameras, and most newer SLRs, have autofocus.

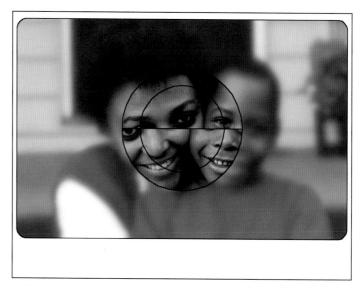

Split image indicates picture out of focus

Manual Focus

To focus manually, simply look through the viewfinder and turn the focusing collar on the lens barrel until your subject looks sharp. Most SLRs have a split-image in the center of the viewfinder that you align for sharp focus. This works best if you can aim at a straight line or sharp edge on your subject.

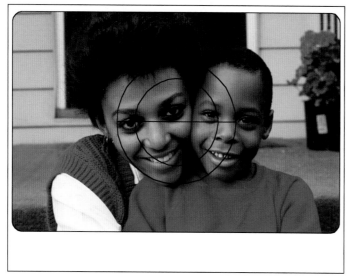

In focus

Autofocus

Autofocus cameras have a small bracket or rectangle in the center of the viewfinder that acts as a focusing frame. To autofocus, aim the frame at your main subject and press the shutter release. Most autofocus cameras provide an audible warning or indicator light in the viewfinder to tell you if the camera is focused.

Autofocus indicator

Without focus lock

Because the focusing frame is in the center of the viewfinder, you have to aim carefully—the camera will focus on whatever is in the frame. If your main subject is off-center—which is often the case in pleasing compositions—you need to lock in the focus.

To photograph off-centered subjects like the one above, aim the focus frame at your subject, then partially depress and hold the shutter release. This focuses the camera and holds it as long as you keep the shutter button halfway down. With the focus locked, you can recompose the scene and then fully depress the shutter release to take the picture. Some autofocus cameras can detect off-center subjects and focus on them automatically, so check your manual for instructions.

Center the subject, lock the focus...

With focus lock
...then recompose the scene and take the picture.

Autofocus Problems

Many autofocus systems depend on subject contrast (light and dark areas) to focus properly. This can be a problem in dim light or in low-contrast scenes like this one. When the autofocus system is having difficulty, you may notice the lens constantly whirring in and out searching for a point of focus.

If the camera has difficulty focusing, look for a small area of contrast—such as a sharp edge on the subject—for the camera to focus on. Lock the focus and recompose to take the picture. The instructions for autofocus cameras usually list the types of subjects that the camera may have trouble focusing on. If all else fails, focus manually.

Exposure

Exposure is the amount of light your film gets when you press the shutter release. Too much light causes overexposure—the picture looks too light, washed out and lacks detail in the brighter subject areas. Too little light causes underexposure—the picture looks dark and muddy. The photo at center is correctly exposed. It shows good color and detail, and the light and dark areas closely resemble the way the scene actually looked.

Underexposure (too little light)

Correct exposure

Overexposure (too much light)

How the Camera Controls Exposure

Film requires a specific amount of light for correct exposure. The parts of a camera that control exposure are the shutter and the aperture. Most 35 mm cameras set exposure automatically, but many cameras also let you set exposure manually. This extra control opens the door to better, more creative photography, so you should understand how shutters and apertures work.

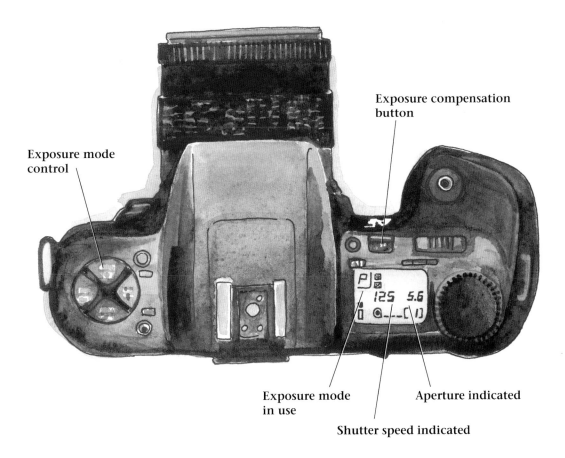

Exposure compensation button

Exposure mode control

Exposure mode in use

Aperture indicated

Shutter speed indicated

Shutter Speed

The shutter speed controls how long light reaches the film. The shutter speeds on most SLR cameras typically run from several seconds to 1/2000 second—some cameras even go up to 1/8000 second. These fractions of a second appear as whole numbers on the LCD panel or shutter-speed dial. If there are numbers for whole seconds, they usually have a letter "S" after them.

In some modes, the camera sets the shutter speed automatically. But most cameras also let you set the shutter speed with either a shutter-speed dial or function control.

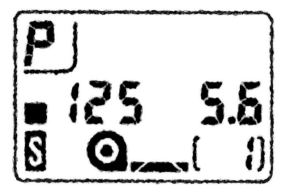

Shutter speed indicated is 1/125 second

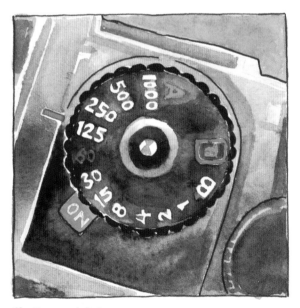

Shutter speed dial

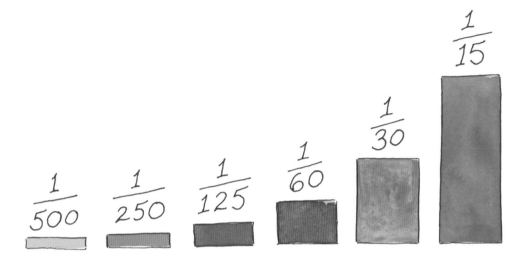

SHUTTER SPEEDS

Notice that each shutter speed is either double or half the speed next to it. Each one-step change either doubles or halves exposure time (and doubles or halves the amount of light reaching the film). For example, if you go from 1/250 to 1/125 second, you double the exposure to let in twice as much light. Similarly, changing from 1/250 to 1/500 cuts the exposure in half, letting in half as much light.

Dimly lighted scenes such as this require slower shutter speeds than brightly lighted scenes.

Brightly lit scenes require fast shutter speeds. Even though this scene is hundreds of times brighter than the first scene, an adjustable camera can control exposure so you will get the picture.

Watch the Shutter Speed

Here's a simple tip that'll pay off in sharper pictures—use a shutter speed number that's at least equal to the focal length of your lens. For example, the slowest shutter speed you should use when hand-holding your camera with a normal (50 mm) lens is 1/60 second. For a 500 mm lens (which magnifies images and camera shake even more), the slowest shutter speed would be 1/500 second. Some cameras will even warn you when the shutter speed gets too slow for hand-holding.

LENS	FOCAL LENGTH	MINIMUM SHUTTER SPEED
	Up to 35 mm	$\frac{1}{30}$
	Up to 60 mm	$\frac{1}{60}$
	Up to 200 mm	$\frac{1}{250}$
	Up to 500 mm	$\frac{1}{500}$

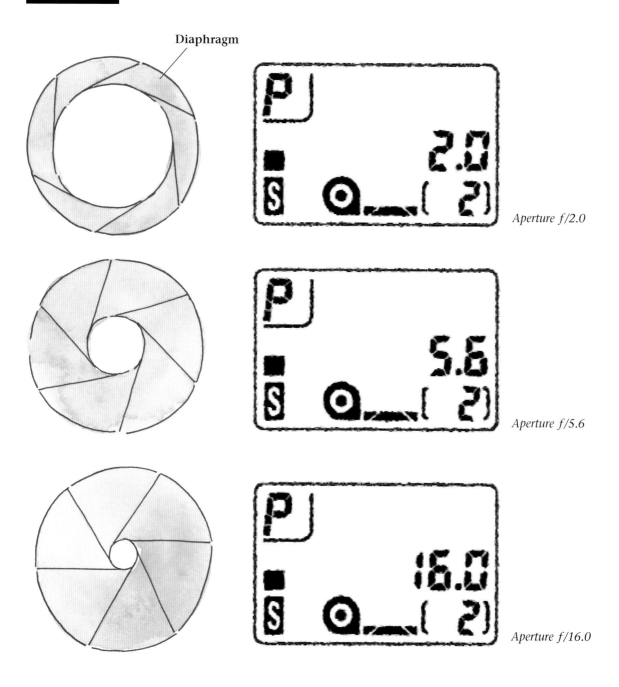

Diaphragm

Aperture f/2.0

Aperture f/5.6

Aperture f/16.0

Aperture

The second way to control exposure is the aperture or lens opening. The opening is formed by an iris-shaped set of blades in the camera lens called the diaphragm. The diaphragm is adjustable, and the different aperture sizes control the amount of the light that strikes the film.

Aperture sizes are identified by a series of numbers called *f*-numbers or *f*-stops. The smaller the *f*-number, the larger the opening in the diaphragm. Likewise, the larger the number, the smaller the opening. An *f*-stop of *f*/2, for example, is large and lets in a lot of light; a setting of *f*/16 is smaller and lets in only a tiny amount of light. The series of *f*-stops shown here is typical of SLR lenses, though most cameras also have intermediate stops for even finer control.

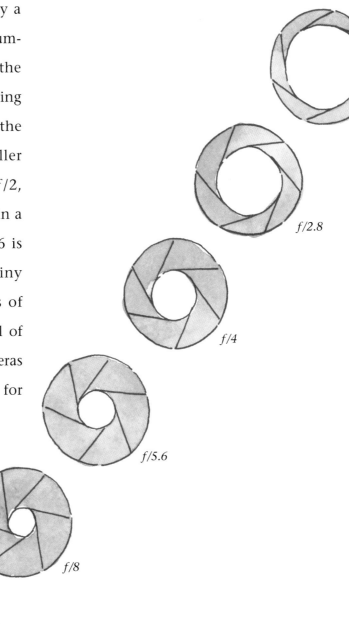

f/2

f/2.8

f/4

f/5.6

f/8

f/11

f/16

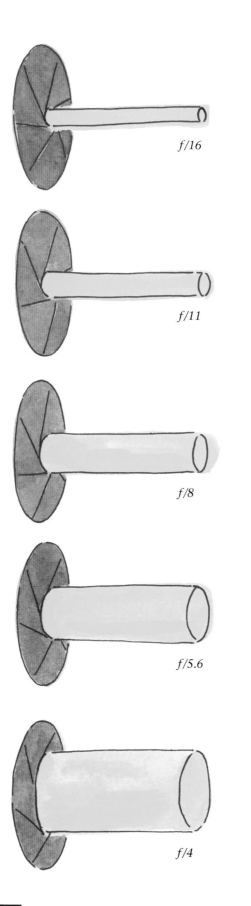

f/16

f/11

f/8

f/5.6

f/4

The change in exposure that you get when you go from one aperture to the next is the same as for shutter speeds. With each full jump up or down the *f*-stop scale, you either double or halve the quantity of light reaching the film. For instance, if you close down the aperture from *f*/5.6 to *f*/8 (one stop smaller), you cut the amount of light in half. If you open up the aperture from *f*/5.6 to *f*/4 (one stop larger), you double the amount of light.

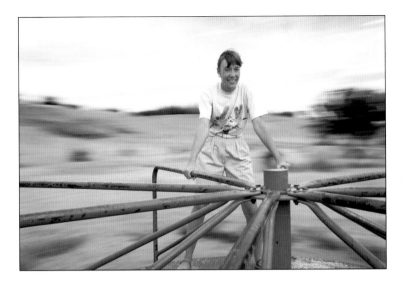

By now it's easy to see that different combinations of shutter speeds and apertures can produce the same exposure, just as both 5 + 1 and 4 + 2 add up to the same amount. Having so many different shutter speed and aperture combinations available allows you to best match a film to a particular subject and lighting situation. The specific exposure combination you select depends on the visual effect you want. Besides controlling exposure, aperture size and shutter speed influence your results in other ways.

Taken at 1/500 second

Shutter Speed and Motion

Because the shutter controls length of exposure, different shutter speeds can affect the perception of motion in your pictures. Fast shutter speeds (such as 1/500 second or greater) freeze motion. The higher the shutter speed, the greater the motion-stopping ability.

Taken at 1/4 second

Slow shutter speeds—usually from 1/30 second to 1/4 second—record moving objects as a blur. You can use slow shutter speeds creatively to reveal the graceful motion of active subjects. Here, the photographer used a shutter speed of 1/4 second.

For the shot below, the photographer used a technique called panning. It yields a fairly sharp subject with a blurred background. To do this, set the camera for a slow or moderate shutter speed, such as 1/60 second, and prefocus on the spot where the subject will pass. As the subject approaches, track it in the viewfinder; shoot without stopping your swing as the subject goes by.

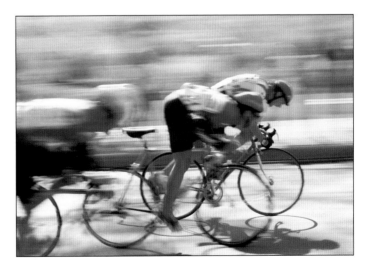

Aperture set at f/16

Aperture Size and Depth of Field

Aperture size also affects image sharpness. When you focus on something, subjects at other distances may look sharp in the picture or they may look unsharp. Each aperture actually produces a range of sharpness called depth of field—this range expands or contracts with different apertures. Knowing how to control depth of field is a very useful creative tool.

Taken at f/16

Small apertures produce greater depth of field. In situations where you want lots of sharpness, from nearby objects to objects far away, use a small aperture (large *f*-number). Above is a picture shot at *f*/16; notice how much of the scene is sharp.

Taken at f/2.8

Here's the same scene shot at an aperture of *f*/2.8 (a larger opening than *f*/16). Notice the blurred background—the range of sharpness is much less.

If you have an SLR camera, you may have noticed that the amount of sharpness you see in the viewfinder isn't always the same as what you get in your pictures. This is because the camera uses the largest available aperture (typically about $f/1.8$) to give you a bright image in the viewfinder while you focus and compose the picture. When you press the shutter release, the camera automatically closes down to the aperture required for proper exposure, and the depth of field changes.

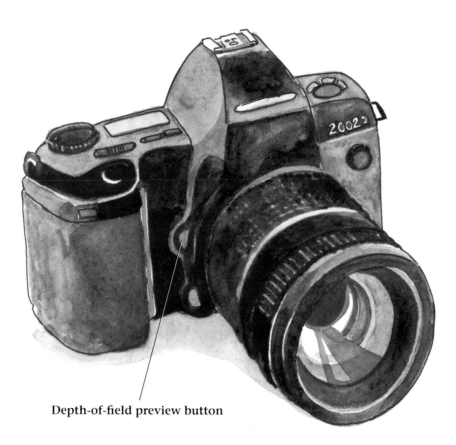

Depth-of-field preview button

Depth-of-Field Preview

If your camera has a depth-of-field preview button, you can see how the sharpness will change before you take the picture. Checking depth of field darkens the viewfinder, but it doesn't affect the actual exposure.

Incidentally, this feature is more common with older-style manual and automatic SLR cameras than it is with autofocus cameras, so check your manual.

For *f*/16, the depth of field is
from 5 feet to almost 20 feet.

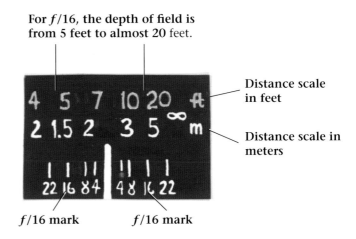

Distance scale
in feet

Distance scale in
meters

f/16 mark *f*/16 mark

The index mark points to subject distance at about 8 feet.

Depth-of-Field Scale

You can also check the range of sharp focus if there is a depth-of-field
scale on your lens. The scale consists of pairs of aperture marks next to the
distance scale. To determine the depth of field, focus on your subject and
then read the two distances that fall opposite the pair of marks for the
aperture you're using. Now focus on a nearer subject and see what happens to the depth of field. It should be smaller for a given aperture. Focus
on a distant subject and see what happens to the depth of field. It should
greatly expand.

Controlling Depth of Field

Here's how to get the most efficient use of depth of field:

1. Focus on the nearest subject you want sharp and note it's distance on the scale. Here the basketball is 7 ft (2 m) from the camera.

2. Focus on the farthest subject you want sharp. Here the boy is 10 ft (3 m) from the camera.

3. Turn the focusing collar until you find a pair of aperture marks that brackets both distances. Here, the marks for f/8 just enclose the near and far distances of 7 ft (2 m) and 10 ft (3 m).

4. For more depth, use a smaller aperture, move farther away from the subject, or use a shorter focal length lens.

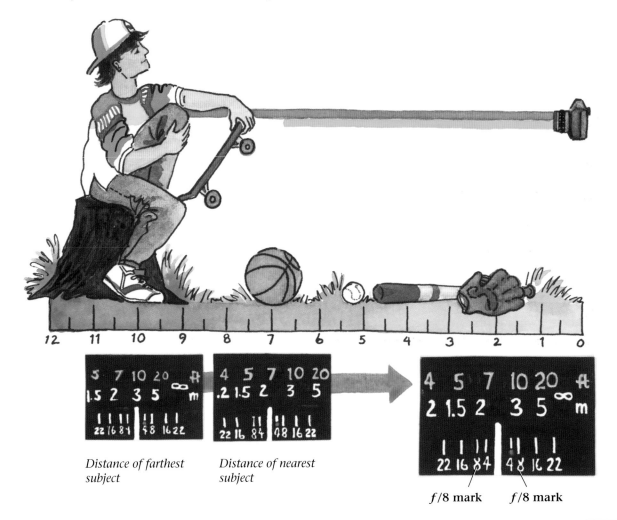

Distance of farthest subject

Distance of nearest subject

f/8 mark f/8 mark

Action or Depth

As we have seen, the combination of shutter speed and aperture that you select can really change the way your pictures look. To choose, you have to decide if it's more important to control action or depth in the picture.

$$1/15 \text{ @ } f22 = 1/60 \text{ @ } f11 = 1/500 \text{ @ } f4$$

Which is the correct pairing? As we've seen, that depends on your creative intent. The important thing is to take control when the situation requires you to do so—don't let the camera make all of the decisions for you.

Exposure Modes

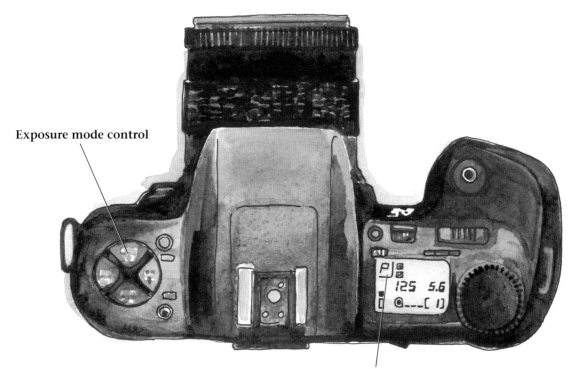

Exposure mode control

Exposure mode in use

Most SLR and bridge cameras offer a choice of exposure modes. This allows you to get correct exposure while also offering you the chance to control certain technical and creative aspects of your photography. By selecting one mode, for instance, you can manipulate depth of field; in another you can freeze action. The key is to pick the mode for the effect you want.

For convenience, much of the exposure information presented on the LCD panel is repeated in the viewfinder.

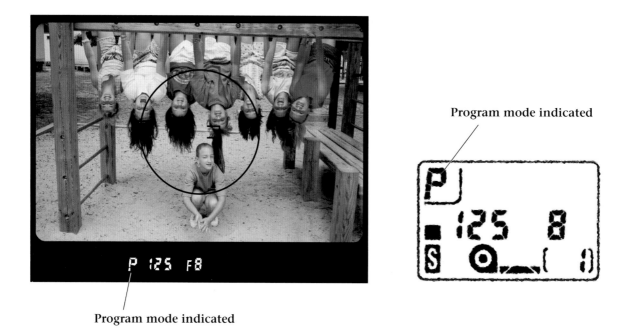

Program mode indicated

Program mode indicated

Program Mode

The normal program (or "P") exposure mode is probably the one you'll use most. The camera sets both the aperture and the shutter speed for you, emphasizing neither. The program tries to choose a shutter speed fast enough to stop moderate action and a medium aperture that will give reasonable depth of field. This is the ideal mode for taking snapshots.

Aperture Priority

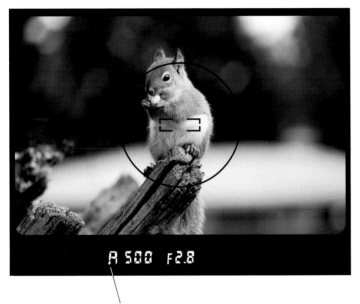

Aperture priority mode indicated

The photographer set the aperture to f/2.8 to blur the background and emphasize the squirrel.

When controlling depth of field is most important, select the aperture priority (or "A") mode. This mode lets **you** choose the aperture while the camera sets the correct shutter speed.

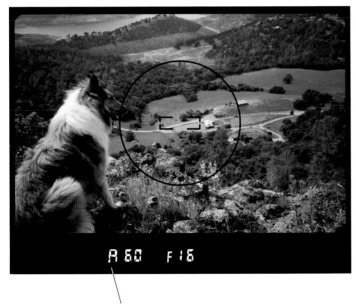

Aperture priority mode indicated

The photographer set the aperture to f/16 so the picture would be sharp from foreground to background.

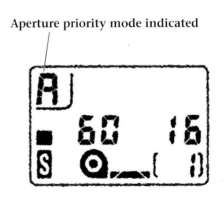

Aperture priority mode indicated

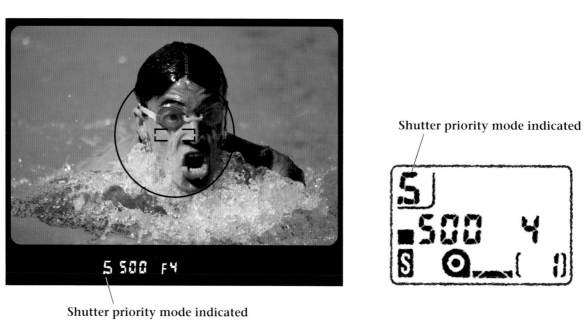

Shutter priority mode indicated

Shutter priority mode indicated

The photographer set the shutter speed to 1/500 second to freeze the action.

Shutter Priority

When you want to stop motion with a very fast shutter speed or exaggerate it with a very slow one, choose the shutter priority ("S") mode. You select a fast or slow shutter speed and the camera picks the aperture that will give correct exposure.

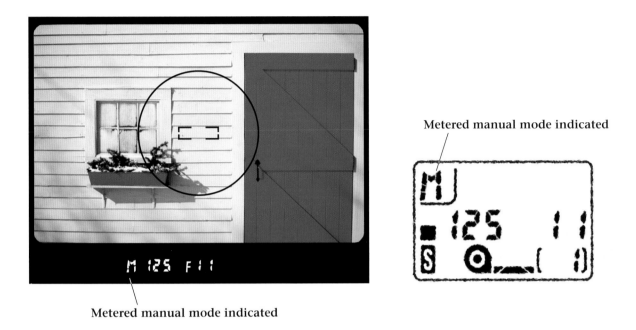

Metered manual mode indicated

Metered manual mode indicated

Metered Manual

Some cameras offer a manual metering mode. You set both the shutter speed
and the aperture based on the exposure recommended by the built-in meter.
You can use this mode when you think the camera's programmed modes
might be fooled (by a very bright or dim subject, for instance), or when you
simply want to override the automatic settings to create special or dramatic
exposure effects.

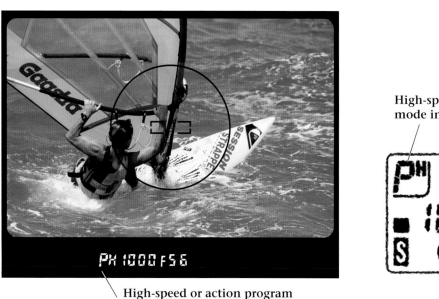

High-speed or action program
mode indicated

High-speed or action program
mode indicated

*The camera automatically set the shutter speed to 1/1000 second to
freeze the action.*

Action or Telephoto Mode

Many SLRs (and some simpler cameras) have a mode called action, or tele-
photo . When you select this mode, the camera automatically sets the fastest
available shutter speed. It also sets the aperture that will give correct expo-
sure. With some cameras, simply attaching a telephoto lens automatically
sets the camera to this fast shutter-speed mode.

Landscape or Depth Mode

Another specialized mode on some cameras is the depth mode—the camera chooses the smallest available aperture to provide maximum sharpness throughout the picture. Some cameras set this mode automatically when you attach a wide-angle lens. This lets you take advantage of the greater depth of field that is characteristic of wide-angle lenses.

Depth or landscape mode indicated

Landscape mode as indicated on a bridge camera

Light Metering

How does your camera know what the correct exposure should be?

Auto-exposure cameras have a built-in light meter that measures the light that passes through the lens. But different camera types measure light differently, and many offer a choice of metering methods. A look in the instruction manual will usually tell you how your camera's meter works so you can use it most effectively.

Averaging Meter

Some built-in light meters take an overall reading of the whole scene to determine exposure settings. These are referred to as averaging meters. Here, sensors come up with an average reading based on the whole picture area, with extra emphasis given to the center. This is based on the assumption that the main subject will be in the middle of the frame, but extremes in lighting or off-center subjects may fool the meter. This type of meter works well in even lighting with subjects of normal reflectance.

Centered-weighted Meter

Cameras with center-weighted meters often feature automatic exposure (AE) lock. This lets you aim at your subject to lock the reading in, then recompose for a more pleasing off-center placement to take the picture. With autofocus cameras, this also locks autofocus and may be referred to as AE/AF lock.

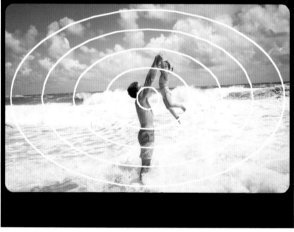

Lock the exposure with the subject centered, then...

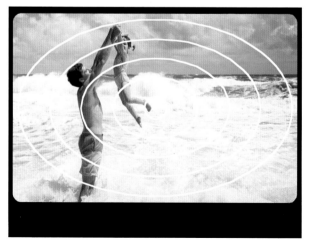

...recompose the subject and take the picture.

Spot Meter

Spot meters take the concept of center-weighted meters a step further. They measure only a tiny area at the center of the viewfinder. But unlike center-weighted meters, spot meters read only that tiny area—they are not affected by exceptionally bright or dark surroundings outside of the metered area. Spot meters are extremely accurate, but it takes practice and experience to know where to aim the metering spot for good results.

Evaluative Meter

A very accurate type of metering system found in many autofocus SLRs is called multipattern, matrix, or evaluative metering. These metering systems divide the viewing area into an invisible jig-saw pattern of four or more segments. Sensors provide readings on the relative size and brightness of subjects in each area, and the camera uses this information to calculate an exposure.

Taking Better Pictures

What's the difference between a basic snapshot and a really interesting photograph? The subjects you choose, the way you arrange them in the frame, and the light that you photograph them in all affect your photographs. There are many approaches to photographic composition, but the basic goal is to select and arrange the elements of a scene in a way that adds impact to the image. The tips on the following pages may not guarantee you great pictures—but they'll put you on the right path.

Eliminate Distractions

The first step is to learn to see—really see what is in the viewfinder. Too often, we concentrate on the main subject so much we don't notice the surroundings. A subject can get lost amid the clutter of a distracting background.

One solution—get closer. This helps to eliminate distractions and gives your picture a main center of interest. If you can't move closer physically, use a telephoto or a zoom lens. A good rule of thumb is to have your main subject fill at least half of the frame.

Use Interesting Viewpoints

Picking the right viewpoint is another way to concentrate your vision. The initial viewpoint that most of us see a subject from is eye-level and straight on. Occasionally this view makes an interesting image, but you will often discover a more eye-catching scenario by exploring your subject from a variety of angles.

High viewpoints are easy to find: a porch, a rock, an upper floor window. High viewpoints help isolate nearby subjects from distracting backgrounds. In more distant scenes, such as landscapes, a high angle de-emphasizes the foreground and often reveals patterns in subjects not seen from eye level.

Looking up from eye-level is normal, but looking up from a kneeling or prone position often reveals bold and surprisingly unusual vistas. Low viewpoints accentuate the height of nearby subjects and can be used to isolate subjects against the sky.

Subject Placement

There is a powerful human urge to place subjects smack in the center of the picture—especially when the focusing frame is in the middle of the viewfinder. But centering subjects tends to eliminate any sense of energy or surprise—and too many centered subjects are boring to look at.

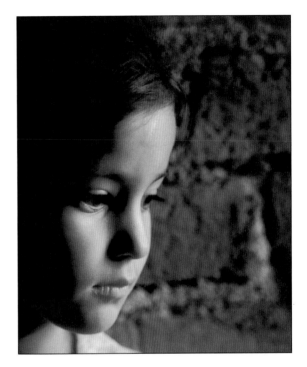

Subjects placed to the left or right, or above or below the center of the frame are more dynamic. One way to determine subject placement is to visually divide a scene into thirds both vertically and horizontally. Any of the four points where the lines intersect provides a pleasing point for your center of interest.

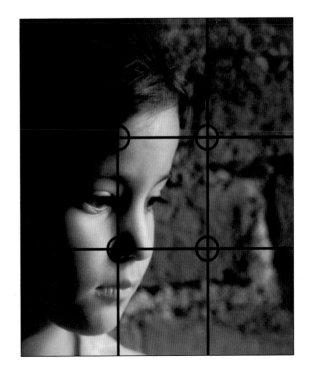

Watch the Horizon

The placement of the horizon in an outdoor photograph is one way to manipulate viewers' interpretations of a scene. As the photo here shows, placing the horizon high in the scene emphasizes the foreground and expands the apparent distance from near to far.

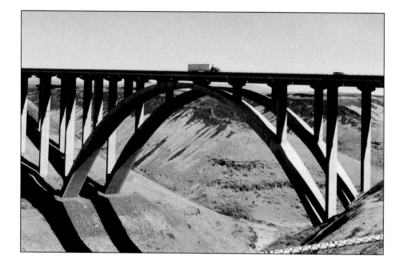

With the horizon set low in the frame, the sky becomes the predominant feature of the photograph and there is an enhanced feeling of space.

It's an age-old axiom that the horizon should never divide the frame exactly in half—but fortunately, none of the rules of photography are scribed in stone. By placing the horizon straight across the center of this tranquil scene, the photographer has created an intriguing mirror image of the subject.

Vary the Format

Most people hold their camera horizontally simply out of habit. Horizontal framing helps compositions when the subject has predominantly horizontal lines—but don't be afraid to turn the camera on end and shoot vertically.

Vertical compositions accentuate the height of tall subjects and often enable you to isolate subjects from cluttered surroundings. The dominant lines of the subject will usually tell you whether a horizontal or vertical viewpoint is best. If it's hard to choose, shoot both ways and decide later.

Exploit Visual Elements

Line

Quite often what attracts our eye to a scene is a particularly strong visual element: line, shape, form, texture, pattern, and color. You can exploit one or more of these elements to enhance your pictures. In this scene, the photographer has used the curving line of a bridge to draw our eye on a journey through the picture.

Shape

Shapes are strong enticements for the eye because they readily identify a subject. A simple way to accent a shape is to silhouette it against an open sky.

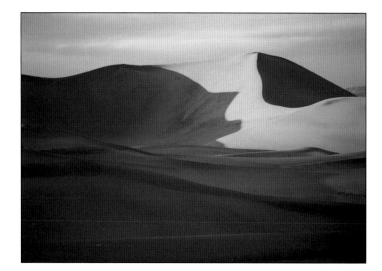

Form

Form reveals the world in its three dimensions. When you add a sense of volume and depth to photographs, you recreate the reality of your subjects. Your viewpoint and use of side light are important tools in showing form.

Texture

The smooth velvet of a cat's fur, the coarse surface of a stucco wall—textures describe the surfaces of objects and bring the imagined world of touch to photographs. Use light coming from the side or rear of a subject to highlight textures.

Pattern

Whenever lines or shapes or other visual elements repeat themselves, they form patterns. Patterns can make great subjects in themselves and they are also a reliable way to bring a sense of order to larger scenes.

Color

Colors, both vibrant and muted, have the power to draw and hold the eye. Distinct splashes of color can be dominant subjects in themselves. Soft pastels create a quiet, more reflective mood in your pictures.

Photograph Ordinary Things

Spectacular subjects can yield sensational photographs—but so can more mundane subjects. Look for visual intrigue in ordinary places and things— whether it's a broken egg shell in the kitchen sink, a stack of clay pots in the garden, or a window. Uncovering the unusual aspects of everyday subjects will lead you to more and better photographs.

Seeing Light

It's easy to look so intently at a subject that we don't actually notice the light illuminating it. But light is what we record on film, so we really should learn to look at how subjects are lit. These two photos show how dramatically light can affect a subject. The two most apparent qualities of light are its direction and its intensity.

Frontlighting

Light that shines from over your shoulder and falls on the front of your subject is called frontlighting. Frontlighting is good when you want to show off strong colors, shapes, and details, but it tends to create flat-looking scenes that lack mood or a sense of depth.

Sidelighting

Light that rakes in from the side of your subject reveals both texture and form. Colors are often quite vibrant when lit from the side and shadows wrap themselves around objects. The play of light and shadow adds depth and dimension in pictures.

Backlighting

Light coming from behind and slightly above a subject can create some very exciting visual effects. In landscape scenes, the long shadows cast toward the lens indicate distance. Strong backlighting can create a luminescent glow in translucent subject elements like leaves, hair, and flowers.

Toplighting

The light of midday shines directly down on subjects and is probably the least appealing lighting: shadows fill eye sockets in portraits and landscapes appear flat and lack depth.

Hard Lighting

Light is also described by its quality: Is it a hard light or a soft light? The strong light of a bright sun accents textures and burnishes brilliant colors, but it also unleashes a merciless mix of black shadows and glaring highlights. The contrast range created by hard lighting is often beyond the ability of the film to record, making exposure difficult.

Diffuse Lighting

Very early or late in the day, or when the sky is overcast, the sun offers a softer, more diffuse light. You can also find it in the open shade of a sheltering tree or building. Diffused light lowers contrast and revives subtle colors. It's also easier to determine your exposure in diffuse lighting. With no deep shadows to hide details, and no bright sun to make people squint, diffuse light is kind to both landscapes and people.

Taking Pictures in Existing Light

Landscapes bathed in the soft afterglow of sunset, city streets by night, portraits by lamplight. Though few photographers seize the opportunities, there are many interesting pictures outdoors after the sun has set, or indoors by available light. Photographs made under these conditions are called existing light pictures. In photography, existing light means dim light. The only special requirements are fast film, a fast lens, and a discerning eye.

Film Choice

High-speed color negative films in the ISO 400 to 1600 range are good choices for existing light pictures. Their higher sensitivity to light lets you take pictures where slower films could not. Color negative films can produce natural-looking colors under a wide variety of light sources without the need for filters.

Color films are designed for use with either daylight or tungsten light. To get accurate color results with slide films, pick one that is balanced for the main type of light that exists in the scene. You can also use filters to make the adjustments you need as indicated in the instructions with the film.

Watch Your Exposure

Determining existing light exposures can be tricky. If possible, take a close-up meter reading of the main subject to determine exposure. As mentioned earlier in this book, some cameras have a spot-metering feature that reads a small area of the scene. As extra insurance, you can bracket exposure by taking extra pictures at a stop or two above and below the exposure indicated by your meter. For example, if the meter indicates 1/60, f/8, also take pictures at 1/60, f/5.6 and 1/60, f/11. You can also use the exposure suggestions in the table on page 118 as a guide.

Existing Light Exposure Table

Use this table as a guide to existing light exposures at night and for indoor events.

EXISTING LIGHT EXPOSURE TABLE

SUBJECT	ISO 64-100	ISO 125-200	ISO 320-400	ISO 800-1000	ISO 1600-3200
Brightly lighted streets	1/30, f2	1/30, f2.8	1/60, f2.8	1/60, f4	1/125, f4
Neon signs	1/30, f4	1/60, f4	1/125, f4	1/125, f5.6	1/125, f8
Floodlighted buildings, monuments	1/4, f2	1/8, f2	1/15, f2	1/30, f2	1/30, f2.8
Skyline - 10 min. after Sunset	1/30, f4	1/60, f4	1/60, f5.6	1/125, f5.6	1/250, f5.6
Skyline - night view of lighted buildings	2 sec., f2	1 sec., f2	1 sec., f2.8	1/2, f2.8	1/4, f2.8
Fairs, amusement parks	1/15, f2	1/30, f2	1/30, f2.8	1/30, f4	1/30, f5.6
Fireworks - time exposure	f8	f11	f16	f22	f22
Burning buildings, campfires, bonfires	1/30, f2.8	1/30, f4	1/60, f4	1/60, f5.6	1/125, f5.6
Night outdoor sports	1/30, f2.8	1/30, f4	1/60, f4	1/125, f4	1/250, f4
Basketball, hockey	1/30, f2	1/60, f2	1/125, f2	1/125, f2.8	1/250, f2.8
Stage shows - Average	1/30, f2	1/30, f2.8	1/60, f2.8	1/125, f2.8	1/250, f2.8
Bright	1/60, f2.8	1/60, f4	1/125, f4	1/250, f4	1/250, f5.6
Circuses, ice shows - Floodlighted acts	1/30, f2	1/30, f2.8	1/60, f2.8	1/125, f2.8	1/250, f2.8
Spotlighted acts	1/60, f2.8	1/125, f2.8	1/250, f2.8	1/250, f4	1/250, f5.6

Protecting Your Equipment

Dust and moisture are your camera's biggest enemies—and fingerprints on your lenses can damage the lens elements and give you blurred pictures. Many photographers protect the front of the lens with a UV or a skylight (No. 1A) filter. And don't forget to use a lens hood.

Lens caps, front and rear, protect your lenses from dirt and scratches. Be especially careful when carrying lenses in a camera bag. Hard or soft lens cases provide even more protection.

If your lens needs cleaning, do it carefully. Lens surfaces are delicate and you should clean them only when it is absolutely necessary. The first step is to blow away all loose bits of dust. You can use either a bulb brush or a can of compressed air designed for photographic applications.

Remove fingerprints and smudges by **gently** wiping the lens surface with a balled-up piece of camera lens cleaning tissue. Dampen it with a few drops of camera lens-cleaning solution (not alcohol or eye-glass solution). Wipe the lens in a circular direction starting at the center and working toward the edges of the lens. And don't forget the rear element of the lens.

It's also important to keep the outside of the camera clean. Remove loose dust with either compressed air or a soft camel's hair brush (not the same brush you use for the lens). Pay particular attention to crevices and seams where loose dirt can work its way inside your camera.

Open the back of your empty camera. Hold it upside down and blow or brush away any dust or film chips. Check the camera each time you load or unload it. If you use compressed air, don't blow on the delicate shutter curtain or you may damage it.

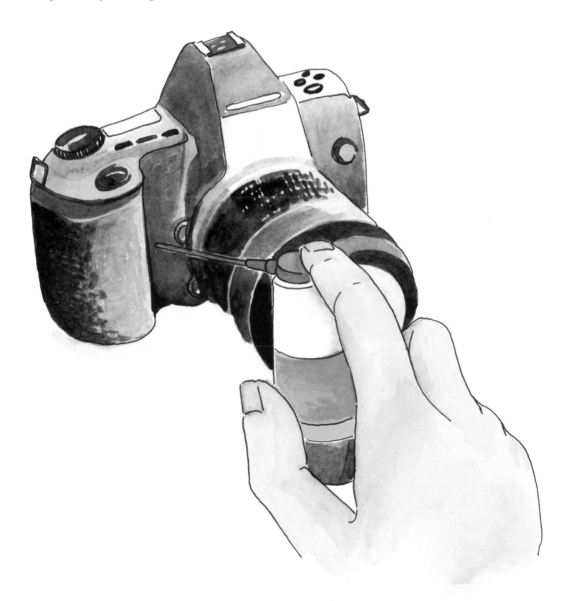

Keep your photo gear away from very hot or very damp places. When it's warm, never leave film or a loaded camera in your car. The dashboard, the back deck, or the glove compartment are really bad spots to leave photo gear. To keep your film and camera cool, and out of sight, put them in a sealed plastic bag in a cooler. Be sure the bag stays dry. Even better, use containers of reusable artificial ice. At the very least, wrap the camera in a towel and place it on the floor under the seat or in the trunk.

Be sure to have fresh batteries handy, especially if you're travelling with your camera. When you're not going to use the camera or flash for a couple of weeks, remove the batteries. Battery life may be exhausted quickly if you take a lot of flash pictures. Slow flash cycle times or erratic camera operation may indicate weak batteries. Most cameras and flash units have a test feature to check battery power.

Glossary of Photographic Terms

Adjustable camera
A camera with manually adjustable settings for distance, lens openings, and shutter speeds.

Angle of view
This is how much of a scene that a lens covers or sees. Angle of view is determined by the focal length. A wide-angle lens (short-focal-length) covers more area than a normal (normal-focal-length) or telephoto (long-focal-length) lens.

Aperture
The opening in a camera lens through which light passes to expose the film. Apertures are marked by *f*-numbers.

Aperture priority
An exposure mode on an automatic or autofocus camera that lets you set the aperture while the camera sets the shutter speed. If you change the aperture, or the light level changes, the shutter speed adjusts automatically.

Autofocus
The camera focuses automatically on the subject that's within the autofocus frame in the viewfinder when you press the shutter release.

Automatic camera
A camera with a built-in exposure meter that automatically adjusts the lens opening and/or shutter speed for proper exposure.

Background
The part of the scene that appears behind the principal subject of the picture.

Backlighting
Light coming from behind the subject and toward the camera lens.

Between-the-lens shutter
A shutter whose blades operate between two elements of the lens.

Blowup
An enlargement; a print that is made larger than the negative or slide.

Bounce lighting
Flash or tungsten light bounced off a reflector (such as a ceiling or walls) to give the effect of natural or available light.

Close-up
A picture taken with the subject close to the camera—usually this means less than two to three feet away, and it can be as close as a few inches.

Color balance
How a color film reproduces the colors of a scene. Color films are made to be exposed by light of a certain color quality such as daylight or tungsten. Color balance also refers to the reproduction of colors in color prints, which can be altered during the printing process.

Composition
The pleasing arrangement of the elements within a scene—the main subject, the foreground and background, and supporting objects.

Contrast
The range of difference in the light to dark areas of a negative, print, or slide (also called density); the brightness range of a subject or the lighting.

Contrasty
Higher-then-normal contrast, including very bright and dark areas.

Cropping
Printing only part of the image that is in the negative or slide, usually for a more pleasing composition. May also refer to the framing of the scene in the viewfinder.

Dedicated flash
A fully automatic flash that works only with specific cameras. Dedicated flash units automatically set the proper flash sync speed and lens aperture, and electronic sensors within the camera automatically control exposure by regulating the amount of light from the flash.

Definition
The clarity of detail in a photograph.

Depth of field
The amount of distance between the nearest and farthest objects that look acceptably sharp in a photograph. Depth of field depends on the lens aperture, the lens focal length, and the subject distance.

Diaphragm
A perforated plate or adjustable opening mounted behind or between the elements of a lens used to control the intensity of light that reaches the film. Openings are usually calibrated in *f*-numbers.

Diffuse lighting
Lighting that is low or moderate in contrast, such as on an overcast day.

Double exposure
Two pictures taken on one frame of film, or two images printed on one piece of photographic paper.

Emulsion
A thin coating of light-sensitive material, usually silver halide in gelatin, in which the image is formed on film and photographic papers.

Enlargement
A print that is larger than the negative or slide: blowup.

Existing light
The existing or available light already on the scene. It includes all artificial illumination indoors or out, twilight, moonlight, and daylight through windows.

Exposure
The quantity of light allowed to act on a photographic material; a product of the intensity (controlled by the lens opening) and the duration (controlled by the shutter speed or enlarging time) of light striking the film or paper.

Exposure latitude
The range of camera exposures, from underexposure to overexposure, that will produce acceptable pictures from a specific film.

Exposure meter
An instrument with a light-sensitive cell that measures the light reflected from or falling on a subject; used as an aid to selecting the exposure setting. The same as a light meter.

Exposure setting
A combination of the lens opening and shutter speed selected to expose the film.

Fill-in light
Additional light from a lamp, flash, or reflector; used to soften or fill in the shadows or dark picture areas caused by the brighter main light. Called fill-in flash when when electronic flash is used.

Film
A photographic emulsion coated on a flexible, transparent, plastic base.

Film leader
The short length of film at the beginning of a roll of film that threads onto the takeup reel in the camera.

Film speed
The sensitivity of a given film to light, indicated by a number such as ISO 200; the higher the number, the more sensitive or faster the film. Note: ISO stands for International Standards Organization.

Filter
A colored piece of glass or other transparent material used over the lens to emphasize, eliminate, or change the color or density of the entire scene or certain elements in the scene.

Finder
A viewing device on a camera to show the subject area that will be recorded on the film. Also known as viewfinder.

Fixed-focus lens
A lens that has been focused in a fixed position by the manufacturer. The user does not have to adjust the focus of this lens.

Flash
A brief, intense burst of light from a flashbulb or an electronic flash unit, usually used where the lighting on the scene is inadequate for picture-taking.

Flat lighting
Lighting that produces very little contrast or modeling on the subject plus a minimum of shadows.

***f*-number**
A number that indicates the size of the lens opening on an adjustable camera. The common *f*-numbers are *f*/1.4, *f*/2, *f*/2.8, *f*/4, *f*/5.6, *f*/8, *f*/11, *f*/16, and *f*/22. The larger the *f*-number, the smaller the lens opening. In this series, *f*/1.4 is the largest lens opening and *f*/22 is the smallest. Also called *f*-stops, they work in conjunction with shutter speeds to indicate exposure settings.

Focal-plane shutter
An opaque curtain containing a slit that moves directly across in front of the film in a camera and allows light to strike (expose) the film.

Focus
Adjustment of the distance setting on a lens to define the subject sharply.

Foreground
The area between the camera and the principal subject.

Frame
One individual picture on a film. Also, tree branch, arch, etc., that frames a subject.

Frontlighting
Light shining on the side of the subject facing the camera.

Graininess
The sand-like or granular appearance of a negative, print, or slide. Graininess becomes more pronounced with faster film and the degree of enlargement.

High contrast
A wide range of density (light and dark areas) in a print or negative.

Highlights
The brightest areas of a subject and the corresponding areas in a negative, a print, or a slide.

Hot shoe
The fitting on the camera that holds a small portable flash. It has an electrical contact that aligns with the contact on the flash unit's "foot" and fires the flash when you press the shutter release. This direct flash-to-camera contact eliminates the need for a PC cord.

Lens
One or more pieces of optical glass or similar material designed to collect and focus rays of light to form a sharp image on the film, paper, or projection screen.

Lens cap
A cap or cover that attaches to the front and/or back of a lens to protect it when not taking pictures.

Lens opening
(See Aperture)

Lens shade
A collar at the front of a lens that keeps unwanted light from striking the lens and causing image flare. May be attached or detachable, and should be sized to the particular lens to avoid vignetting.

Lens-shutter camera
A camera with the shutter built into the lens; the viewfinder and picture-taking lens are separate.

Lens speed
The largest lens opening (smallest f-number) at which a lens can be set. A fast lens transmit more light and has a larger opening than a slow lens.

Light meter
(see Exposure meter)

Monopod
A one-legged support used to hold the camera steady. Sometimes called a unipod.

Negative
The developed film that contains a reversed-tone image of the original in an enlarger.

Normal lens
A lens that makes the image in a photograph appear in perspective similar to that of the original scene. A normal lens has a shorter focal length and a wider field of view than a telephoto lens, and a longer focal length and narrower field of view than a wide-angle lens.

Off-the-film (OTF) metering
Meter determines exposure by reading light reflected from the film during picture-taking.

Overexposure
A condition in which too much light reaches the film, producing a dense negative or a very light print or slide.

Panning
Moving the camera so that the image of a moving object remains in the same relative position in the viewfinder as you take a picture.

Panorama
A broad view, usually scenic.

Parallax
With a lens-shutter camera, parallax is the difference between what the viewfinder sees and what the camera records, especially at close distances. This is caused by the separation between the viewfinder and the picture-taking lens. There is no parallax with single-lens-reflex cameras.

Perforations
Regularly and accurately spaced holes punched along the edges of 35 mm film to transport the film through the camera.

Positive
The opposite of a negative; an image with the same tonal relationships as those in the original scene—for example, a finished print or a slide.

Processing
Developing, fixing, and washing exposed photographic film or paper to produce either a negative image or a positive image.

Program Exposure
An exposure mode on an automatic or autofocus camera that automatically sets both the aperture and the shutter speed for proper exposure.

Push-processing
Increasing the development time of a film to increase its effective speed after using a higher-than-rated ISO number for the initial exposure; useful for low-light situations. Also called forced development.

Retouching
Altering a print or negative after development with dyes or pencils to alter tones of high-lights, shadows, and other details, or to remove blemishes.

Selective focus
Choosing a lens opening that produces shallow depth of field. This usually isolates a subject by causing most other elements in the scene to be blurred.

Shutter
A curtain or set of blades in a camera that controls the time during which light reaches the film. The shutter opens and closes when you press the shutter release.

Shutter priority
An exposure mode on an automatic or autofocus camera that lets you select the desired shutter speed, and the camera sets the aperture for proper exposure. If you change the shutter speed, or the light level changes, the camera adjusts the aperture automatically.

Sidelighting
Light striking the subject from the side relative to the position of the camera; produces shadows and highlights to enhance the sense of depth, form, and texture in a scene.

Simple camera
A camera with few or no adjustments. Usually, simple cameras have only one size of lens opening and one or two shutter speeds, and do not require focusing.

Single-lens-reflex (SLR) camera
A camera in which you view the scene through the same lens that takes the picture.

Slide
A photographic transparency mounted for projection.

Soft focus
Produced by use of a special lens that creates soft outlines.

Soft lighting
(See Diffuse lighting)

Telephoto lens
A lens that makes a subject appear larger on film than does a normal lens at the same camera-to-subject distance. A telephoto lens has a longer focal length and narrower field of view than a normal lens.

Through-the-lens (TTL) metering
A meter built into the camera determines exposure for the scene by reading light that passes through the lens during picture-taking.

Time exposure
A comparatively long exposure made in seconds or minutes.

Tone
The degree of lightness or darkness in any given area of a print; also referred to as value. Cold tones (bluish) and warm tones (reddish) refer to the color of the image in both black-and-white and color photographs.

Transparency
A positive photographic image on film, viewed or projected by shining light through film.

Tripod
A three-legged supporting stand used to hold the camera steady. Especially useful when using slow shutter speeds and/or telephoto lenses.

Tungsten light
Light from regular room lamps and ceiling fixtures, not fluorescent.

Underexposure
A condition in which too little light reaches the film, producing a thin negative, a dark slide, or a muddy-looking print.

Viewfinder
(See Finder)

Vignetting
A fall-off in brightness at the edges of an image, slide, or print. Can be caused by poor lens design, using a lenshood not matched to the lens, or attaching too many filters to the front of the lens.

Wide-angle lens
A lens that has a shorter focal length and a wider field of view (includes more subject area) than a normal lens.

Zoom lens
A lens in which you adjust the focal length over a wide range. In effect, this gives you lenses of many focal lengths.

Index

Photo Credits

The majority of these pictures are from the Kodak International Newspaper Snapshot Awards (KINSA) and the Kodak/Parade Magazine photo contest. These yearly contests are for amateur photographers like yourself. If you'd like to enter the KINSA contest, call your local paper to see if they participate. It usually starts around June.

Page	Photographer
iv	Patricia Timm
13	Steve Kelly
25	Arthur Allen
26	Marshall Spears (top)
	Don Chamberlin (bottom)
27	Jim Franklin (top)
	Joseph Janowicz (bottom)
28	Larry Johnson (both)
30	Susan A. Winchell
31	Fred Snyder (all)
33	Joseph Janowicz
37	Tom Hough (both)
38	Tom Hough
48	Derek Doeffinger (both)
49	John Gormly (top)
	John Gormly (center)
	Fred Snyder (bottom)
50	John Gormly (top)
	John Gormly (center)
	Bob Harris (bottom)
56	Gary Whelpley (top)
	Christine Lindberg (bottom)
57	Don Cochran (top)
	Norm Kerr (bottom)
58	Terry Seil (top)
	Steve Kelly (bottom)
63	Steve Kelly
64	Walt Lee (both)
65	Merlyn Shaffer
66	Kimberly Henry (top)
	Liz Rumpelsberger (bottom)
67	Arnold Levy
68	Fred Snyder (all)
72	Adam Corbitt (top)
	George Butt (bottom)
77	Brian Turner (top)
	Roberto Romanda (center)
	Laurie Barnhart (bottom)
78	David Michell
79	Link H. Davis (top)
	Nick Leung (bottom)
80	Janet Holl

Page	Photographer
81	Bob Zolla (both)
82	Bob Zolla
88	Elizabeth McNamara
89	Elaine Sullivan (top)
	Emma Wilson (bottom)
90	Arturo Valles
91	Tyler Gillin
92	Steve Kelly
93	Derek Doeffinger
94	Kevin Bollman
95	Phyllis Olson
96	Mary Rueham
97	Doris Barker
98	Bea De Alba De Tello
99	Art Wallace
100	Lisa McDavid (both)
101	Don Cochran
102	Derek Doeffinger (top)
	Joseph Janowicz (bottom)
103	Gerardo Andrade (both)
104	Daniel Rodriguez, Jr. (top)
	Agnes Emineth (bottom)
105	Virginia Avery
106	Jodi Nilsson (top)
	Norm Kerr (bottom)
107	Morris Guariglia (top)
	J.W. Fry (bottom)
108	Kodak Image Library (top)
	Jodi Collins (bottom)
109	Cheri Johnson (top)
	Don Cochran (center)
	Betty Gable (bottom)
110	Carole Koontz
111	Tom Hough (both)
112	Robert Vass (top)
	Todd Sharp (bottom)
113	John Menihan (top)
	John Buczynski (bottom)
114	B.J. Gruling (top)
	Jerry Huhaida, Jr. (bottom)
115	Steve Kelly
117	Norm Kerr